POEMS AND PEN DRAWINGS

POEMS AND PEN DRAWINGS BY ALAN SWIFT

Other works by Alan Swift

Psychotic Symptoms

Homage

Parables of a Schizophrenic Poet

Copyright © 2014 by Alan Swift

All rights reserved. This book or any portion thereof may not be reproduced or used in any manner whatsoever without the express written permission of the publisher except for the use of brief quotations in a book review or scholarly journal.

First printing 2014

ISBN: 978-1-326-12396-3

Alan.swift348@btinternet.com

swozza@hotmail.co.uk

DEDICATION

I dedicate this book to all the would be artists and poets, prophets, mystics and misunderstood seers who through whatever circumstances or substances used or abused have come to be labelled as having a mental illness.

ACKNOWLEDGEMENTS

This book has come about due to the inspiration of Sarah Hatcher who revealed the art of Zentangle at an open day for the 5 Borough's Partnership Recovery College. She led me to regain my enthusiasm for art and I have merged my art with my poetry and so I would also like to say a big thank you to the writers' group at The Citadel in St. Helens chaired by Terry Caffrey for all their support and encouragement. Once again I am indebted to Martin Bates, fellow author, for introducing me to Lulu.com and a big thank you to my fiancée Joan Cummings for her love and support and patience.

PREFACE

There is hope! Where there is life there is hope and where there is life there is death, and yet no one really knows what death is until they die despite what others may claim.

This book is a book of hope and inspiration. The Bible says that we are made in the image and likeness of the Godhead and since He/She is The Creator we are co-creators with Her/Him. To fulfil our life's purpose we need to create, whatever that may be. For some it could be a career or a hobby, raising a family, joining a cause or a movement.

When I was younger I wanted to be an inventor and created things with my hands through woodwork and metalwork. Nowadays I write and draw and am thrilled with the creative potential of the internet and computers. This short book is my latest project and includes some of my original artwork tastefully scanned and inserted into my documents. I hope it brings a ray of sunshine into you and your loved ones lives and there is always hope as I was

diagnosed with schizophrenia over 25 years ago and I am now leading a fulfilling life full of laughter and tears and everything in-between, thanks to medication, meditation, family and friends, support groups, hobbies and projects and I suppose, wisdom or life experience, through maturing over the years (as I have now passed the half century mark and I am still breathing!).

Alan Swift

December 2014

Table of Contents

poems and pen drawings by alan swift 2
dedication ... 6
acknowledgements ... 7
preface ... 8
A Buddhist carol .. 13
In memory of mary ... 15
religion .. 17
Why? ... 19
zentangle ... 21
kirkstall ... 23
fading memories ... 25
zen cube .. 27
dynamic doodling .. 29
hand ... 31
music, musings and madness 33
conclusion ... 34
bibliography ... 35

Poems and Pen Drawings

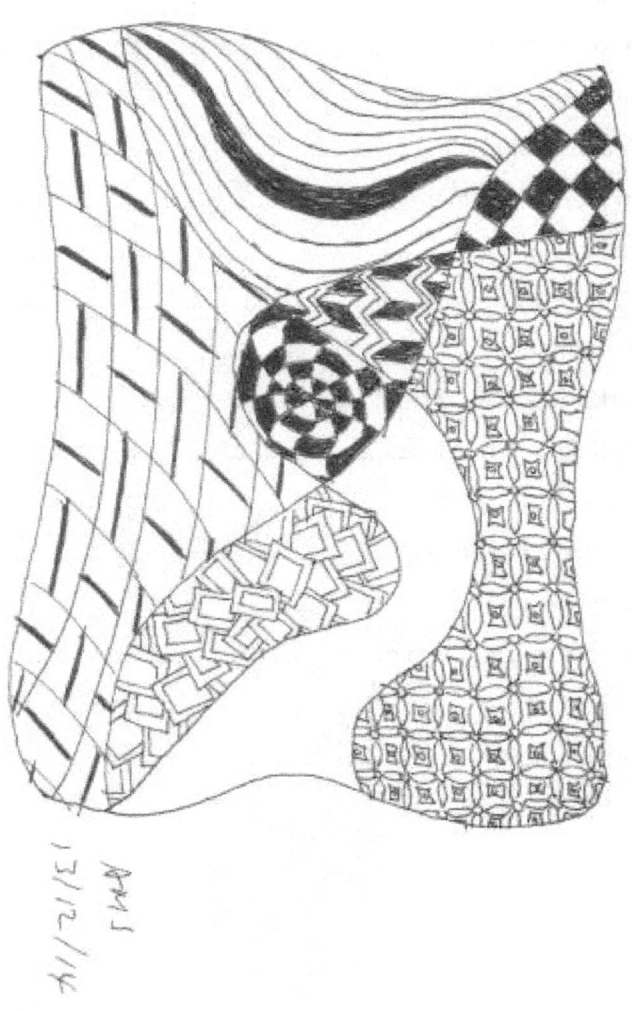

Alan Swift

A BUDDHIST CAROL

Beyond enlightenment

There is no quest.

Beyond enlightenment

There is no goal.

Beyond enlightenment

Nirvana is illusion.

Beyond enlightenment

Suffering is unfounded.

Beyond enlightenment

Nothing matters

And beyond enlightenment words are just sounds

And sounds are without meaning

In a never ending universe

Where Buddha and Christ shake hands

Bearing gifts of love and contentment

Beneath the trees of eternity

Far beyond the Christmas season.

Poems and Pen Drawings

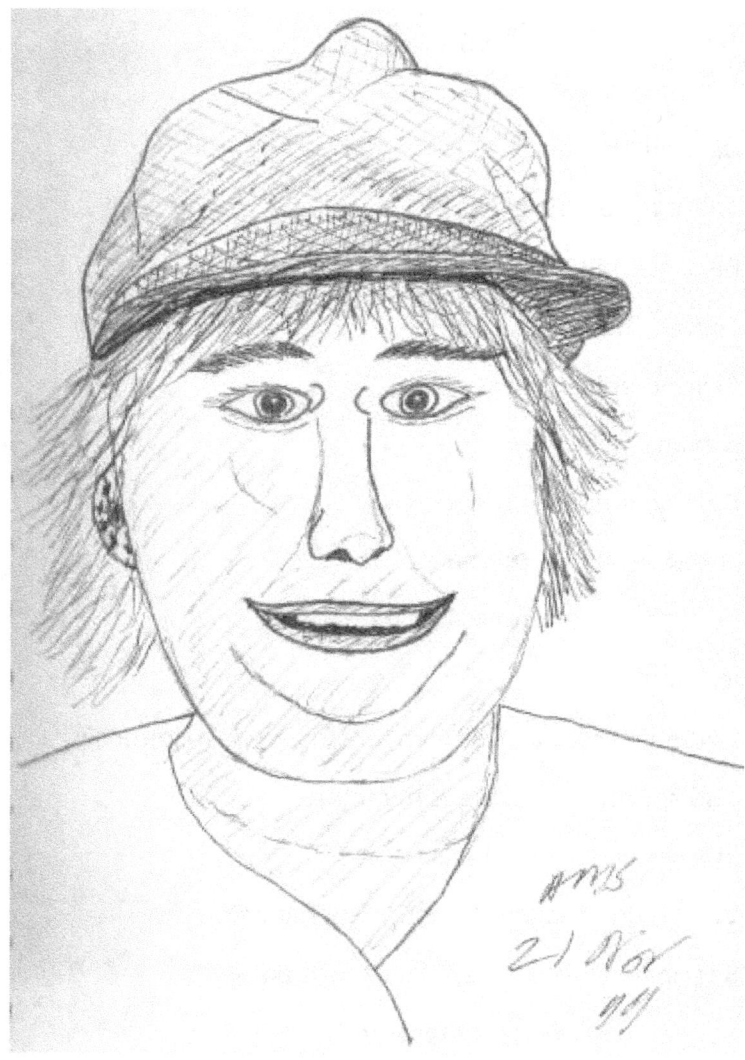

Alan Swift

IN MEMORY OF MARY

She had a hard and tragic life,

Being a mother and a wife in the 1960's

But she got by as she had no choice.

Diagnosed and drugged by men in white coats,

Manic depression was the label they claimed,

Mood swings and mayhem with a son and a husband to care for,

That was the reality,

And back in the 1960's medication was minimal,

Untried and untested with side effects, many,

Far worse than today.

And though she is no longer here in her physical form,

At rest and at peace,

I believe she is still with me trying to express the love she found so hard to receive.

Poems and Pen Drawings

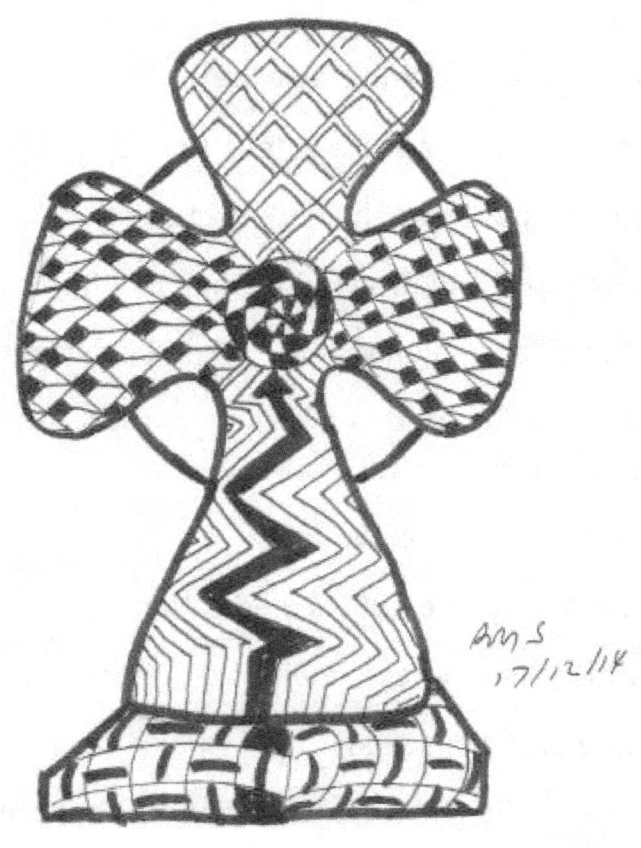

RELIGION

I was brought up in the Roman Church,

And for many years,

Unwillingly,

On a Sunday,

I would go to Mass.

I saw hypocrisy and lies,

Walking hand in hand,

For those in search of salvation and a good time,

And I didn't want to be a part of it,

And yet the programming I received as a child,

Is, oh so hard, to dismiss,

Even though I have embraced spirituality in place of religion now,

Will I ever be free?

Poems and Pen Drawings

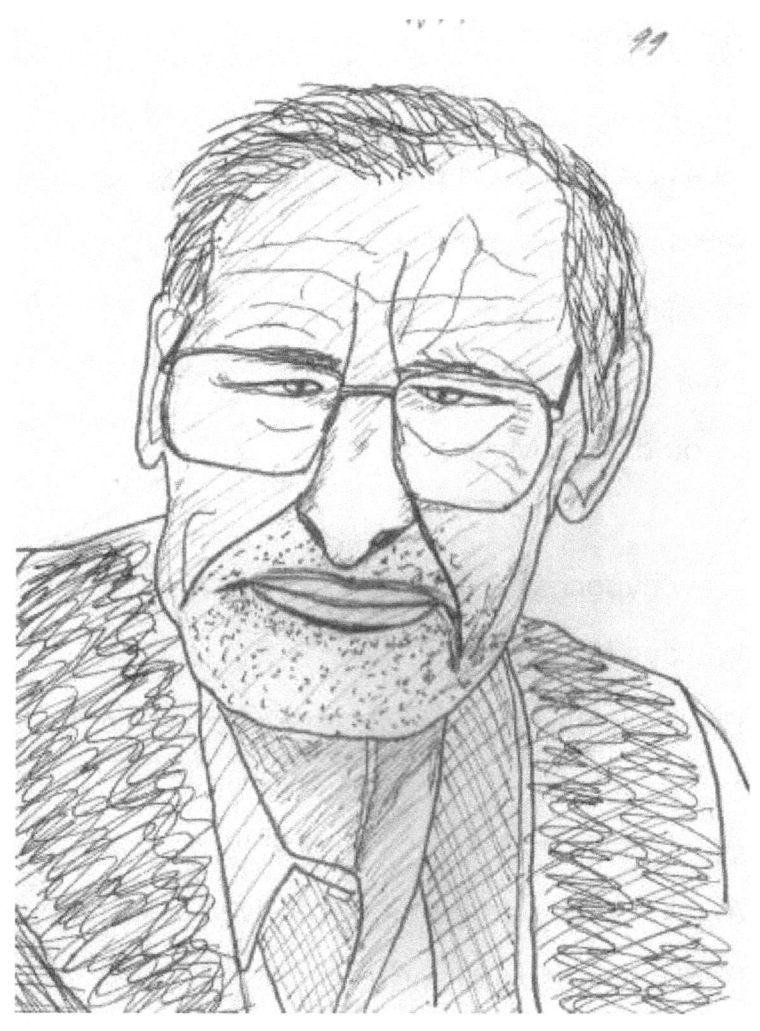

Alan Swift

WHY?

For years you stuck by us,

When others would have given up,

And I cannot but wonder why?

Faithful to your vows,

And faithful to your conscience,

I can but wonder,

How you managed for so long?

Even to the end and beyond,

And all I can but say is,

"Thank You Dad and were you scared?"

Poems and Pen Drawings

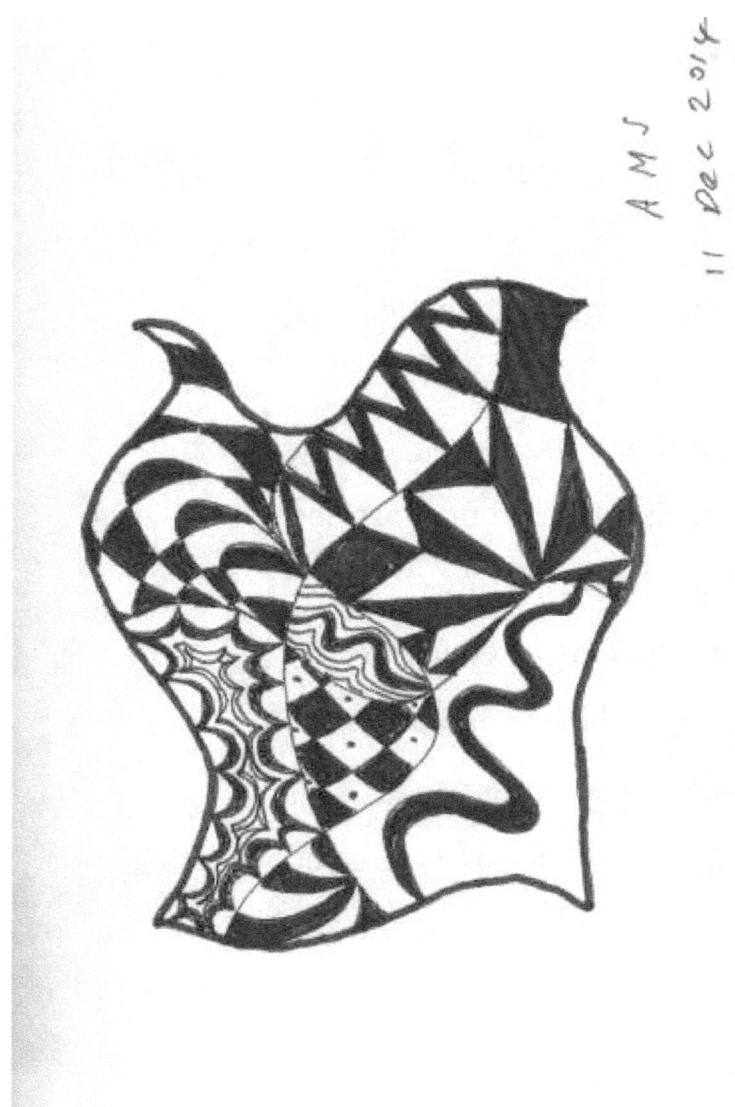

ZENTANGLE

Is it art on drugs you ask?

Or is it simply that you cannot draw?

Is it the pentatonic scale applied to sight?

Simple and pleasing to the eye?

Yet requiring little skill,

Ideal for the timid,

Who dare not reproduce reality?

And yet I like it and it is relaxing,

And yes, I'm publishing them in this book,

And yes I can draw,

It's simply this form of art is called Zentangle!

Poems and Pen Drawings

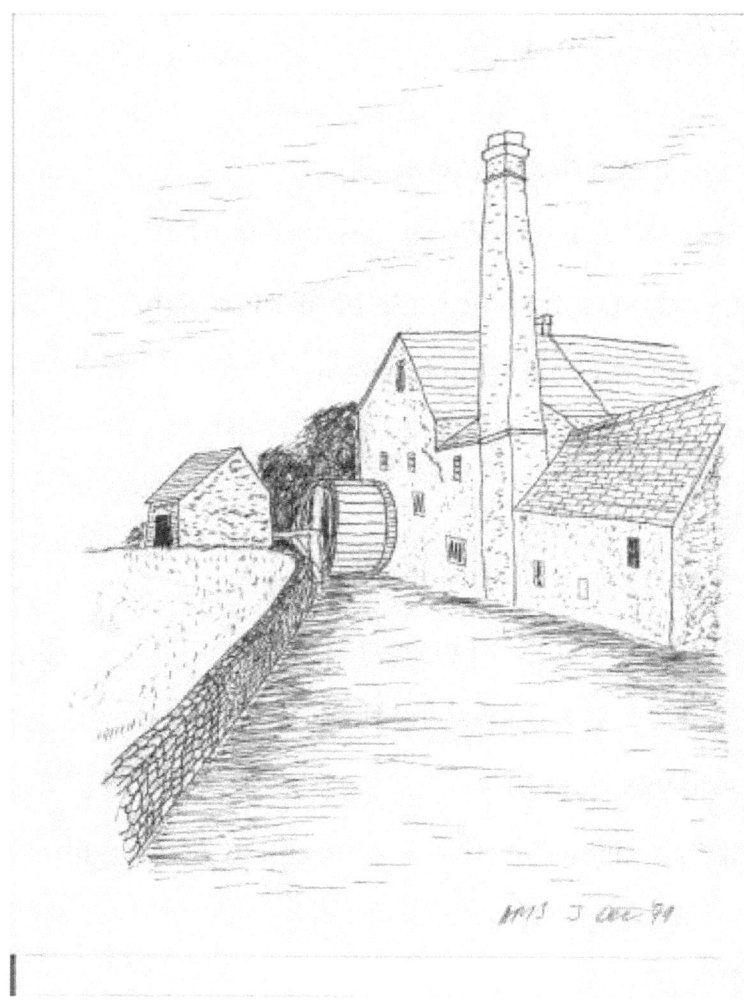

Alan Swift

KIRKSTALL

I lived and I languished in Leeds,

For less than a year,

Leaving the University of Lancaster,

Without qualifications,

And in need of a job,

But I was not ready,

So I walked down by the mill,

In search of myself,

And silence.

Poems and Pen Drawings

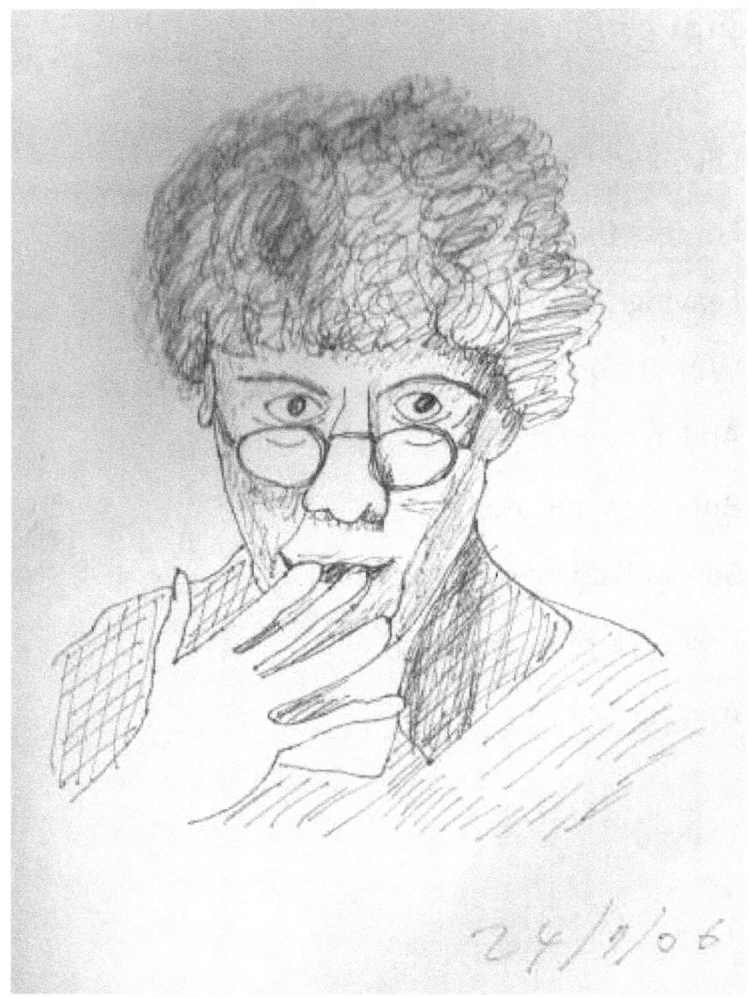

Alan Swift

FADING MEMORIES

I look back at my pictures and what do I see,

An old woman with glasses,

But who is she?

Has she Alzheimer's?

Or is it just me?

Whoever it is,

I cannot remember!

Poems and Pen Drawings

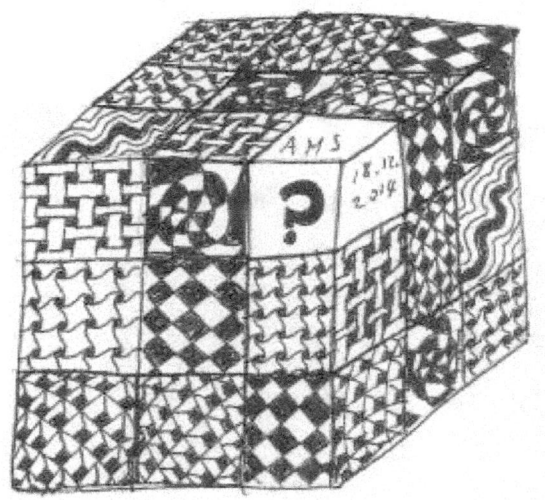

Alan Swift

ZEN CUBE

Life is a mystery,

Unsolvable,

Like a Zen Koan,

Or a Rubik's cube.

Life is a treasure,

Life is a pleasure,

So long as there's peace of mind,

For life may bring happiness,

And life may bring sorrow,

But where there is hope,

There is always today and always tomorrow.

Death is a mystery,

Yet to be solved,

Like a Zen Koan,

Or a Rubik's cube.

Poems and Pen Drawings

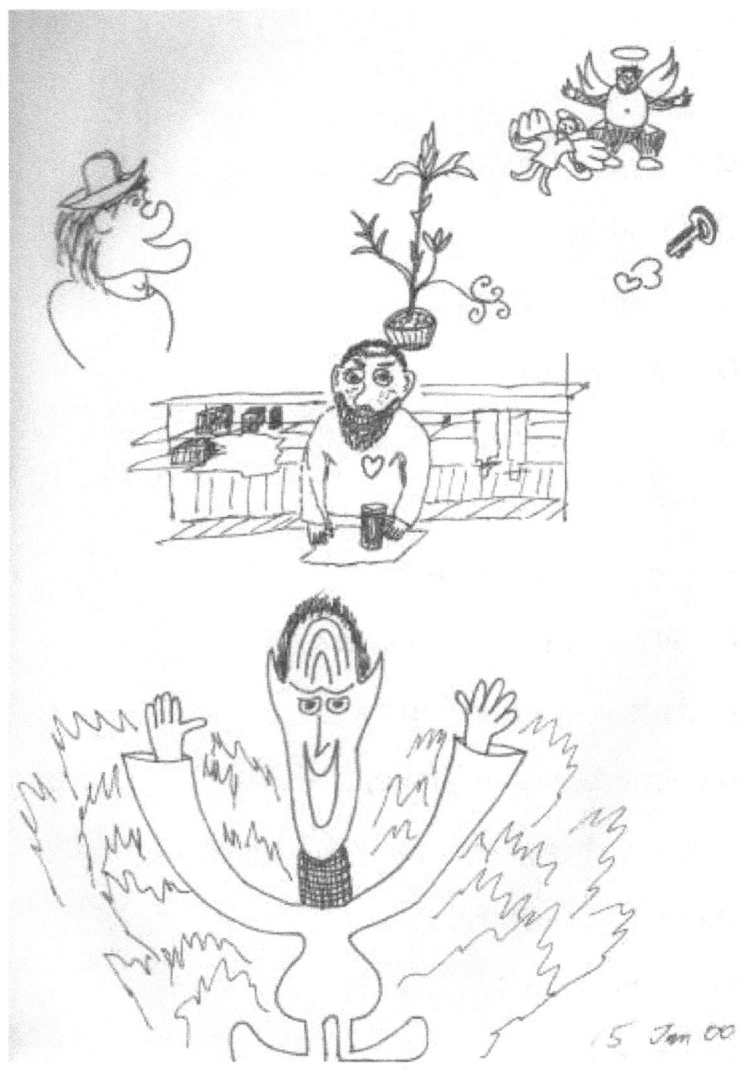

Alan Swift

DYNAMIC DOODLING

Discover yourself through drawing,

Discover yourself through doodling,

Discover yourself through drooling,

Drawing, drooling, doodling,

It's all the same if you ask me,

And you can do it anytime,

Any place,

Anyway,

And in any order,

But don't drool on the page,

You may spoil your artwork!

Poems and Pen Drawings

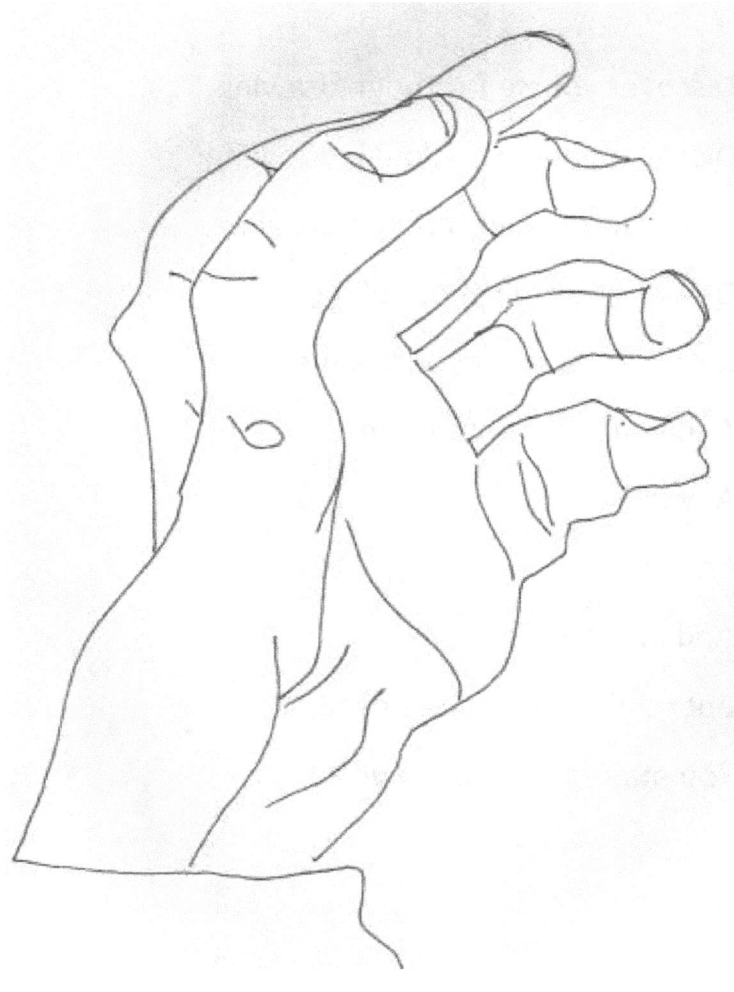

Alan Swift

HAND

The hand has so many uses,

Noble and ignoble,

A truly marvellous tool,

When controlled by a master.

So does the Almighty have a hand?

With what did the Creator create?

In this life there are things we cannot know,

And yet it does not matter,

Life is here to be enjoyed,

And a joy shared,

Is a joy doubled,

So share and celebrate,

And treasure all moments of happiness.

Poems and Pen Drawings

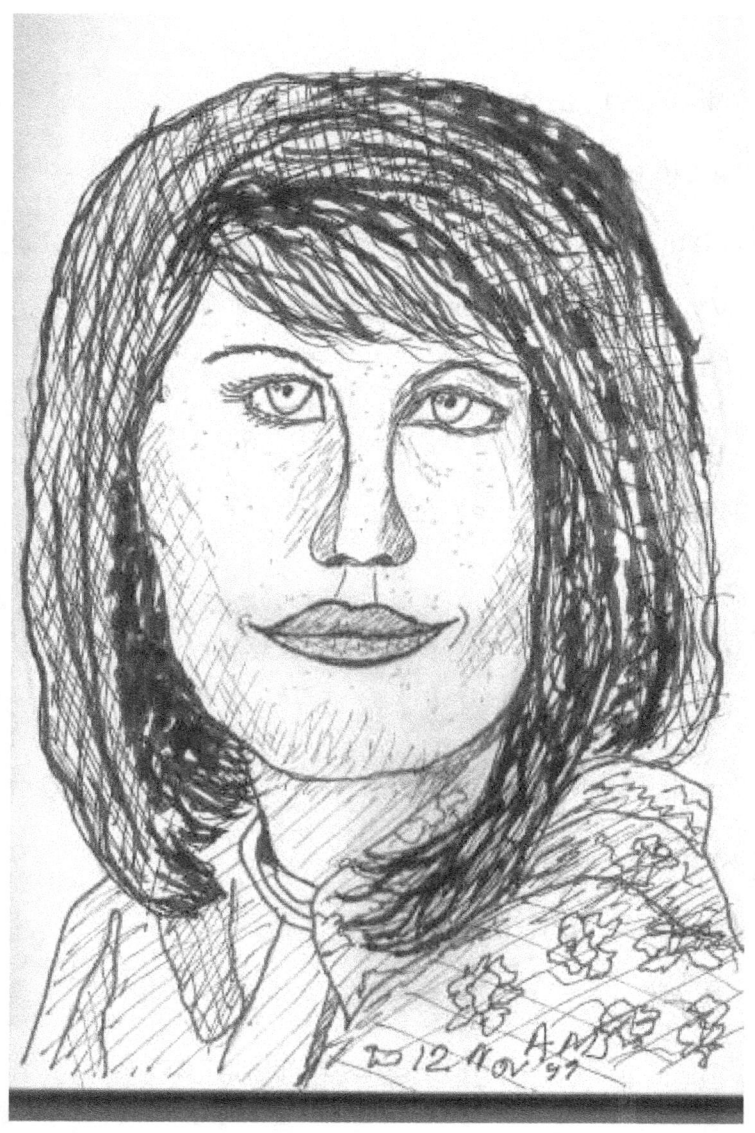

Alan Swift

MUSIC, MUSINGS AND MADNESS

Why is it necessary to suffer to be creative?

It isn't: it's just that people tend to use creativity to relieve the tension of unbearable sorrow when tragedy strikes its hapless victims.

Musicians, artists, poets, writers, sculptors, inventors, mystics, madmen, madwomen and all genuinely creative people are just more sensitive than the general population.

Creativity can be cultivated if one was not disposed to it, because everyone is creative, though not always in healthy ways.

Creativity is nice but it comes with a price! The question is can you afford it? And are you willing to pay that much? And do you still want it?

CONCLUSION

I know this is a short book but I hope it has inspired you, as it has inspired me to do further works, possibly longer. We are all creative, if we but believe!

Alan Swift

BIBLIOGRAPHY

I read a lot of books and so have many sources of inspiration but the two authors who inspired my artwork are as follows:

Betty Edwards: Drawing on the Right Side of the Brain.

Suzanne McNeill: Zentangle 1, 2, and 3.

www.ingramcontent.com/pod-product-compliance
Lightning Source LLC
Chambersburg PA
CBHW072309170526
45158CB00003BA/1246